Long Melford

Stained Glass Colouring Book

Text by Simon Edge

Original photography by Chris Parkinson

EYE BOOKS

Published in 2022
by Eye Books Ltd
29A Barrow Street
Much Wenlock
Shropshire TF13 6EN

www.eye-books.com

British Library Cataloguing in Publication Data
A catalogue record for this book is available from the British Library.

Printed by CPI Group (UK) Ltd, Croydon CR0 4YY

ISBN 9781785633416

All proceeds from the sale of this book go to the Long Melford Stained Glass Restoration Fund

Long Melford is a tranquil village in the southwestern part of Suffolk, a sparsely populated county with no cities and no motorway running through it, which today feels remoter than it really is from busier parts of the country.

In medieval times, Suffolk was anything but a backwater. It was the most densely populated county in England, as well as the richest. It owed its prosperity to a thriving wool trade centred on a handful of places dedicated entirely to that industry. As one of those settlements, Long Melford was among the wealthiest towns in Europe.

The area's prosperity was at its height in the fifteenth century, when the English aristocracy was also divided into two warring factions. One supported the ruling Lancastrian dynasty of the monkish King Henry VI and his French wife Margaret of Anjou; the other backed a challenge to the throne from the House of York in the shape of the usurping Edward IV, who deposed Henry in 1461.

East Anglia was spared any of the great battles of the Wars of the Roses, but many of its aristocrats and landowners were key players. In Long Melford, wool tycoon John Clopton of Kentwell Hall – who was Sheriff of both Suffolk and Norfolk – backed the Lancastrian cause, as did his close friend John de Vere, 12th Earl of Oxford, lord of the manor in the neighbouring wool town of Lavenham.

Corresponding with the exiled Queen Margaret to try and restore Henry VI to the throne, the earl was betrayed by his courier. De Vere, along with his eldest son Aubrey, plus John Clopton and three knights of the realm, were arrested and imprisoned in the Tower of London. In February 1462, Oxford's son was executed in front of him, then he himself was disembowelled, castrated and burned alive. The three knights imprisoned for their role in the conspiracy were beheaded. Only Clopton was pardoned and allowed to go free. Returning to Long Melford, he devoted the rest of his life to the support of the new Yorkist royal family and to building a magnificent church, giving thanks not just for the wealth of the wool trade but also for his own survival.

On the site of a previous church on high ground at the upper end of the village, the new Holy Trinity was constructed between 1462 and 1484. Vast in size, it remains one of the most celebrated medieval churches in Britain. Simon Schama calls it 'an extraordinary example of both spectacle and sophistication' while the architectural historian Sir Nikolaus Pevsner described it as 'one of the most moving parish churches of England: large, proud and noble'.

It was built in the Perpendicular style, with as little stone and as much glass as possible. As a result its window area is enormous, flooding the interior with natural light. In medieval times, these windows were glazed with elaborate scenes in stained glass, a medieval art form which flourished in England and was then at the peak of its sophistication.

Tragically, as much as ninety per cent of English medieval stained glass was smashed either in the Reformation, following Henry VIII's breach with Rome – his son Edward VI ordered religious imagery in churches to be destroyed – or a century later, in the Civil War, when Puritan vandals tried to obliterate anything the previous generation of zealots had missed.

Long Melford's magnificent church was by no means immune to these waves of destruction. However, the sheer area of windows

made it hard for the state-sponsored iconoclasts to destroy everything.

What survived is an array of stained glass unique in England. The images the zealots didn't destroy are mainly secular, showing the family, friends and associates of John Clopton, some of whom may have given him money for the construction of the church. Their nearly life-size portraits provide an unparalleled record of fifteenth-century costumes, heraldry and hairstyles – as well as a line-up of Suffolk dignitaries and their wives, some of them familiar names in the history of the Wars of the Roses.

Other glass in the church includes a remarkable *Pietà* image of the crucified Christ in the Virgin Mary's arms – one of only four surviving examples in English medieval stained glass.

As Simon Jenkins says in his classic guide *England's Thousand Best Churches*: 'The surviving glass records a plutocracy that must have deterred even the most determined iconoclast...a roll call of kneeling donors and associated saints and heraldry, God and mammon in magnificent union...'

We hope you enjoy getting to know these wonderful images as you colour them in.

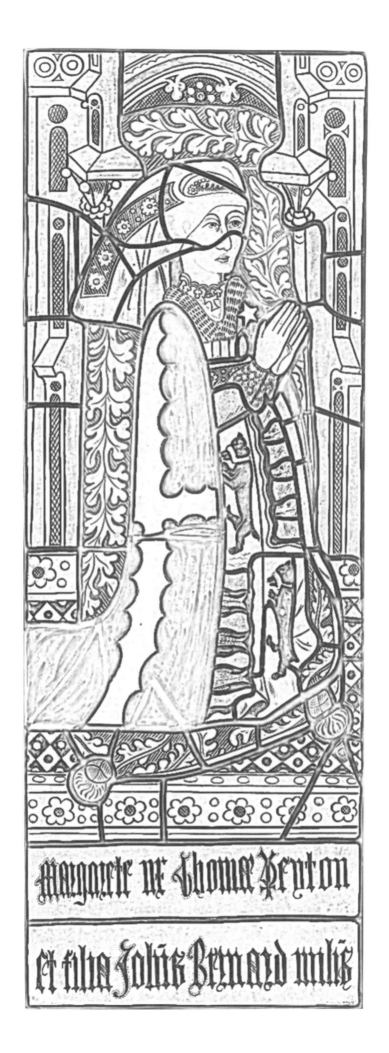

2

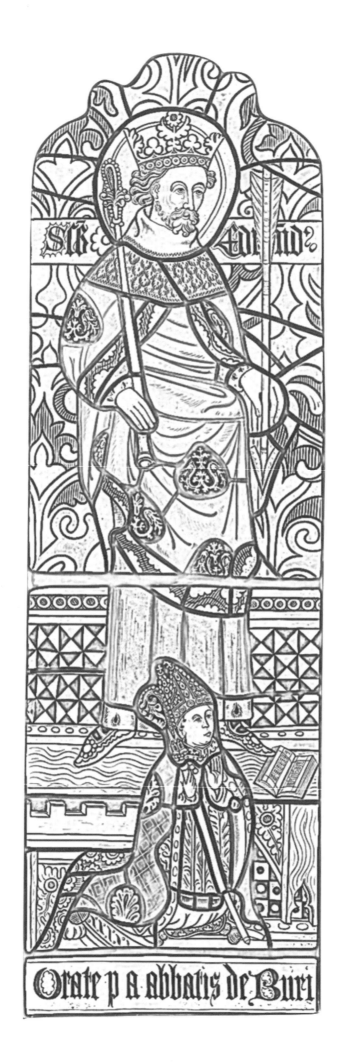

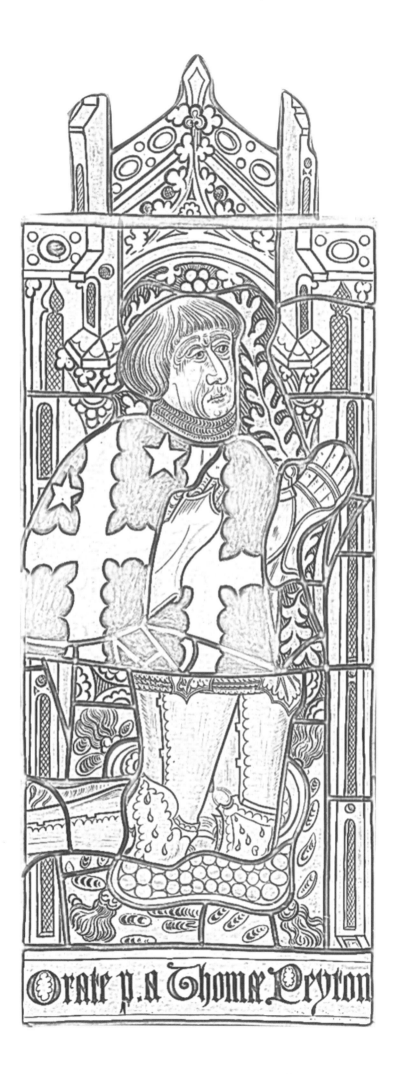

Orate p. a Thomæ Peyton

4

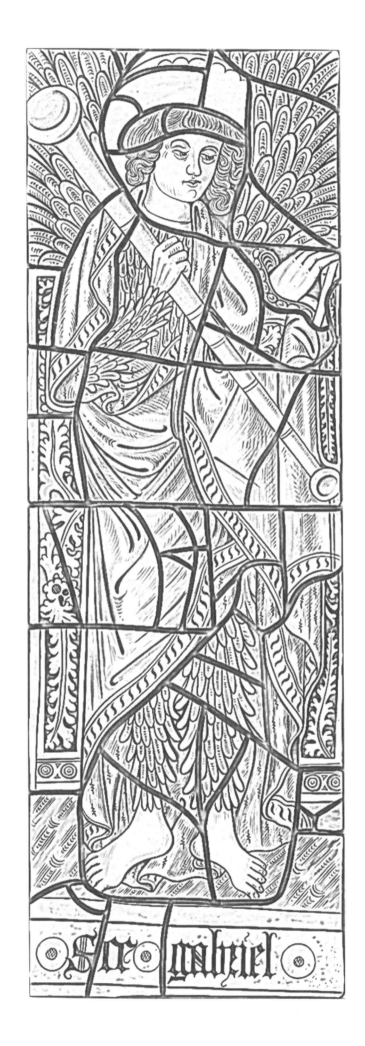

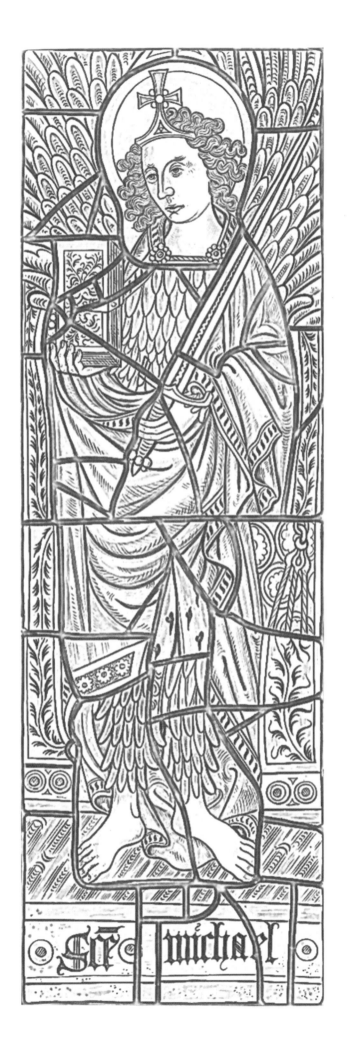

6

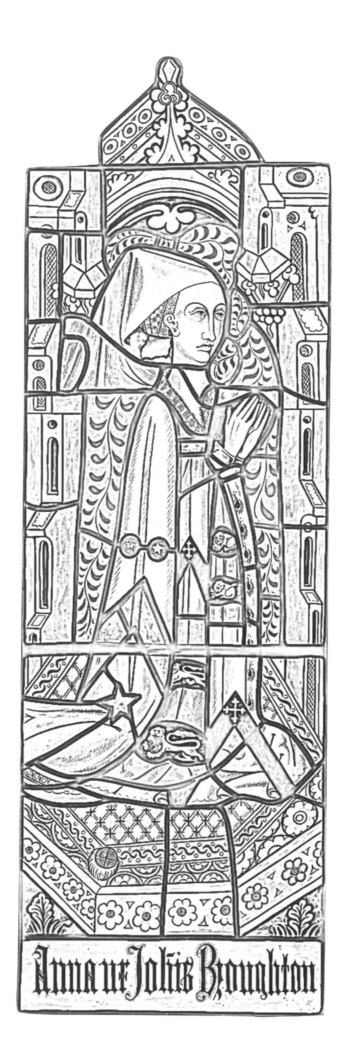

Anna ux Johis Broughton

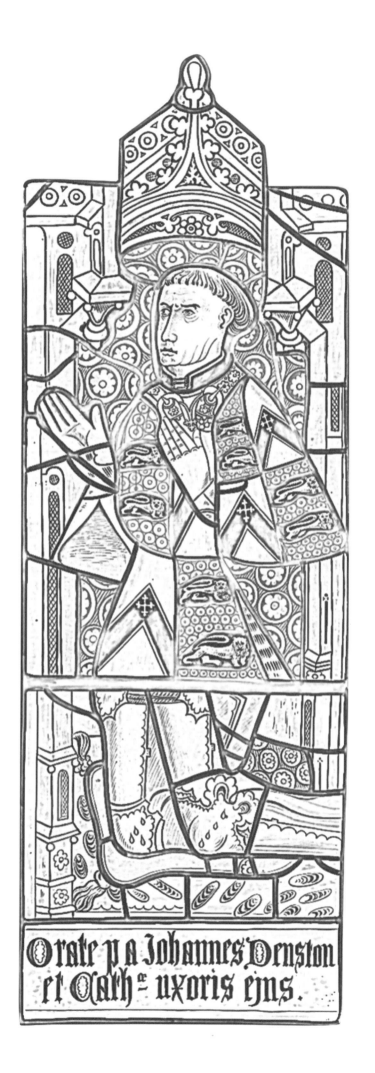

Orate p̄ a̅ Iohannes Denston
et Cath̄ uxoris ejus.

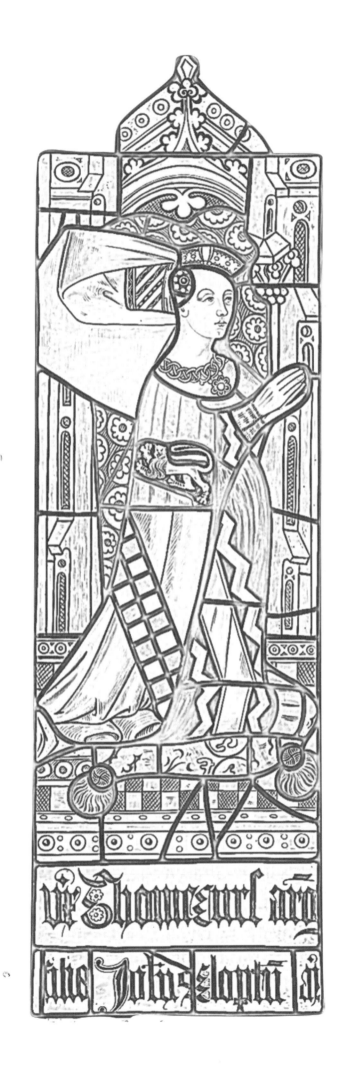

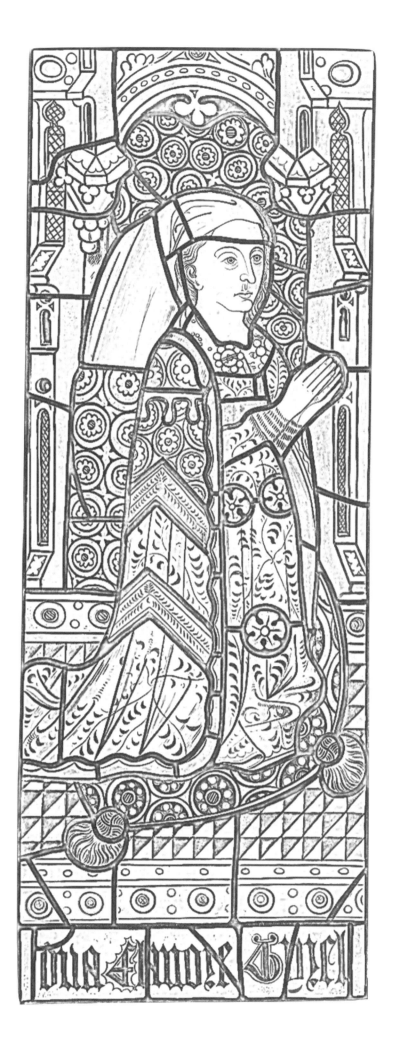

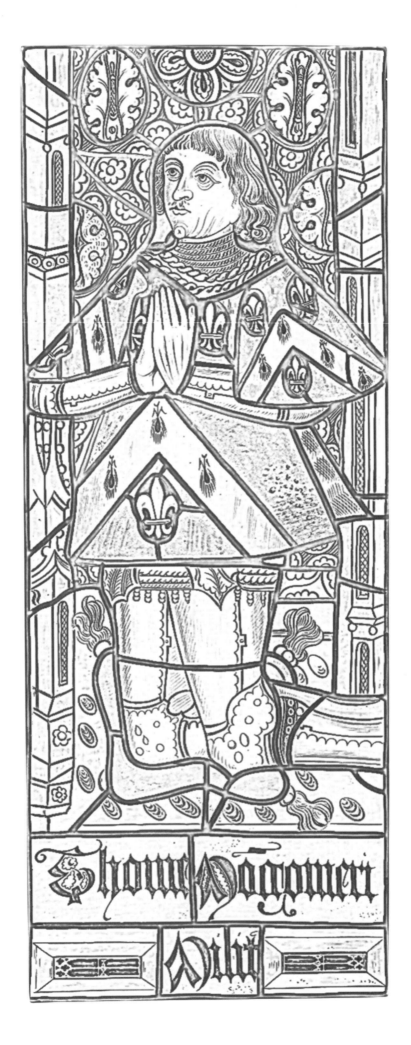

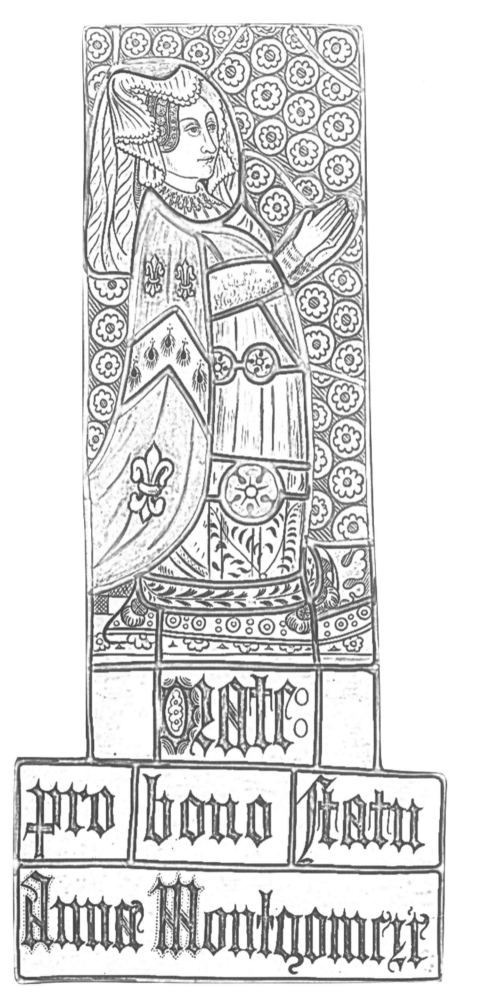

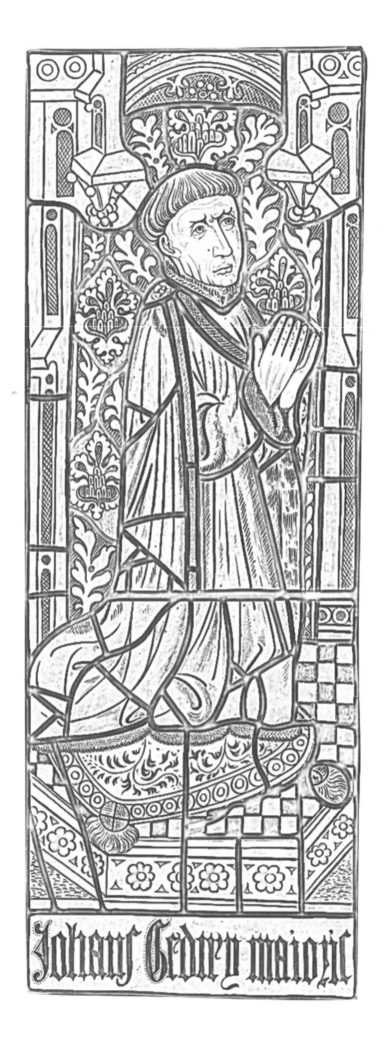

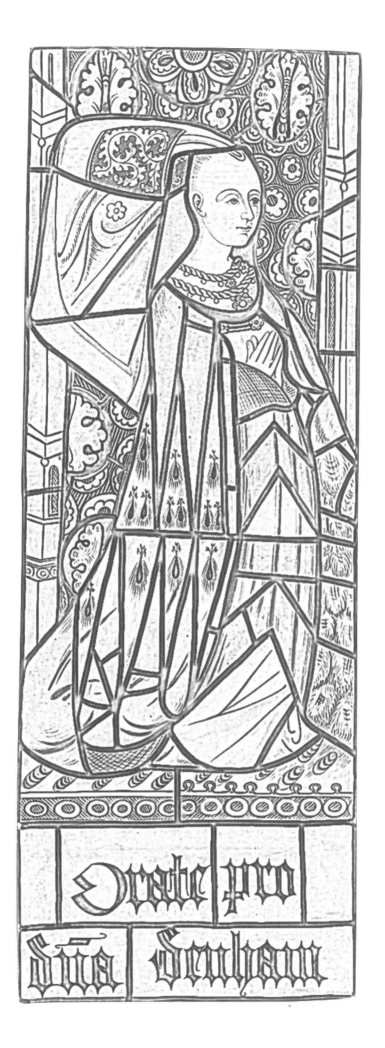

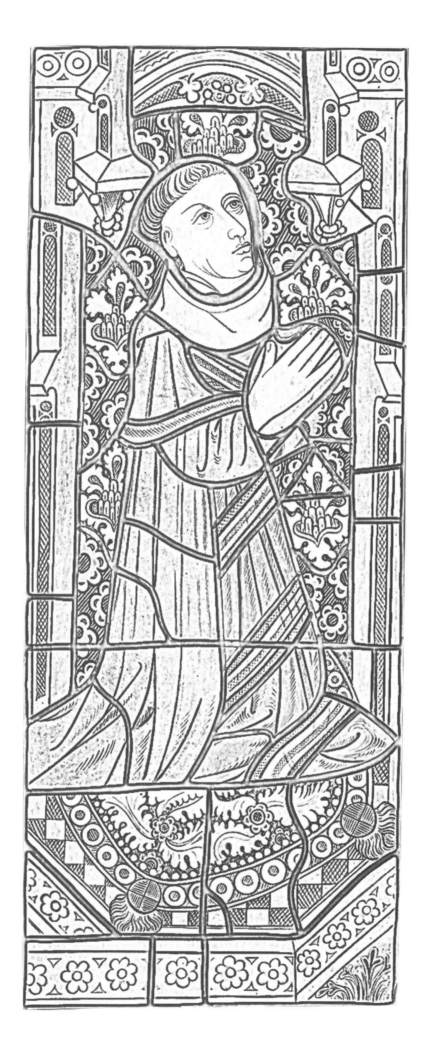

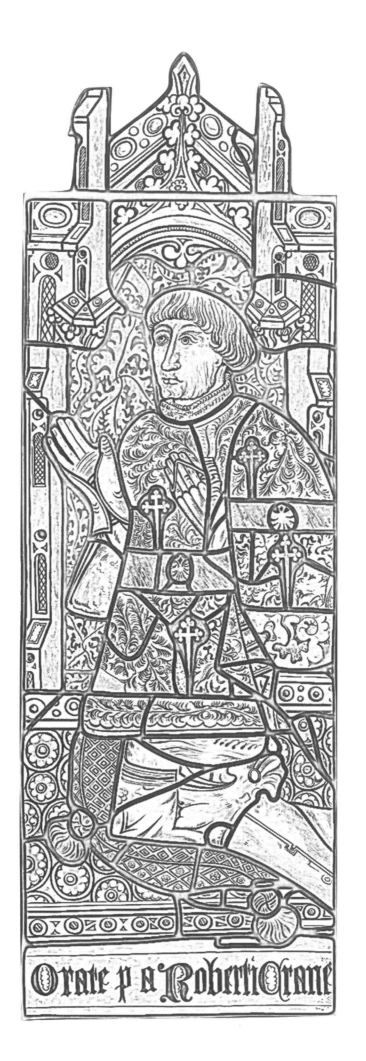

Orate p a' Roberti Crane

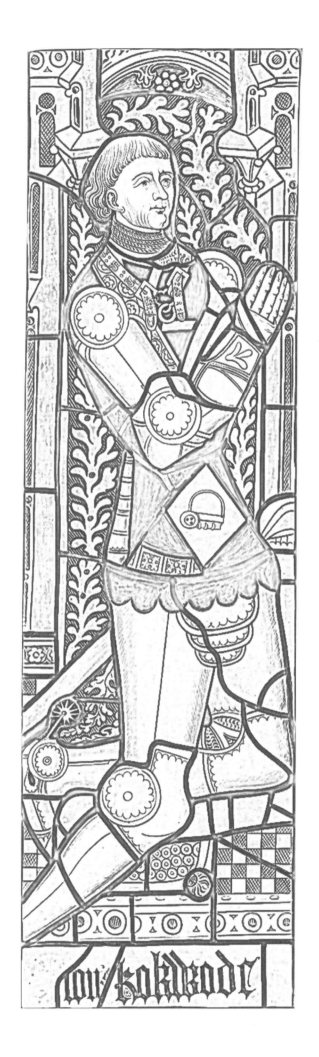

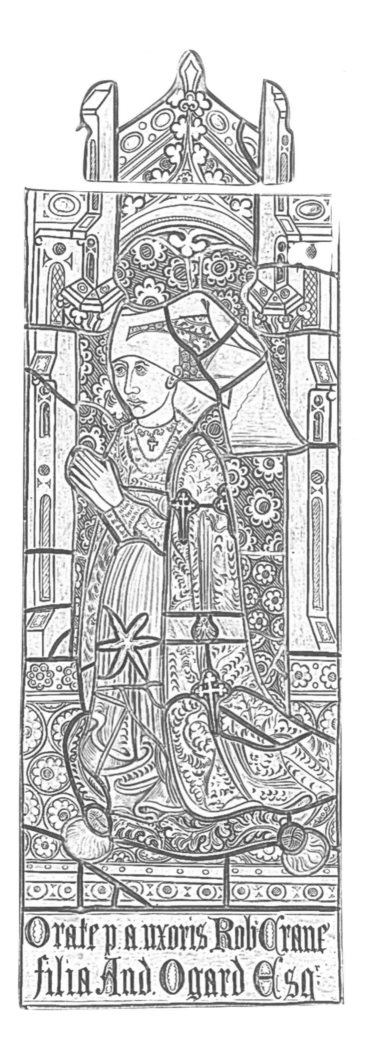

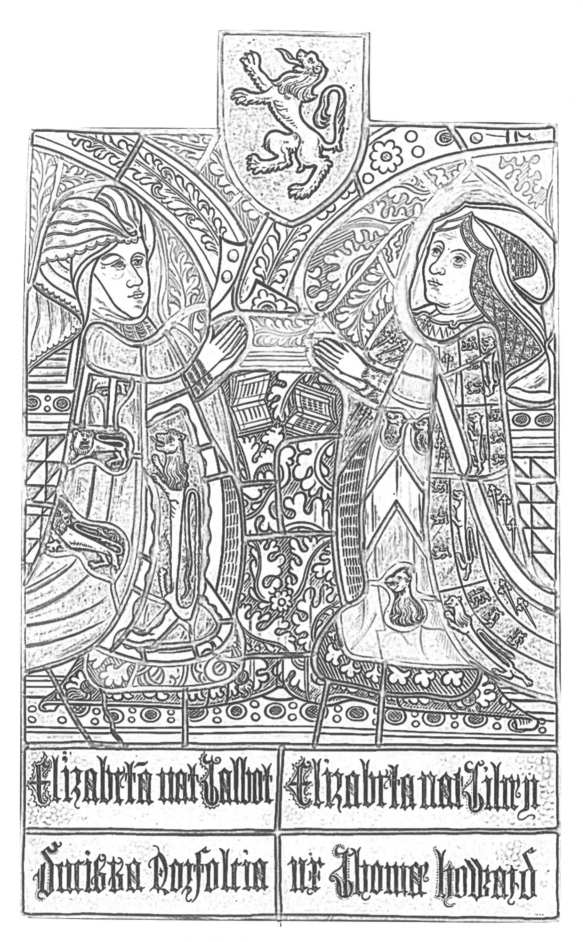

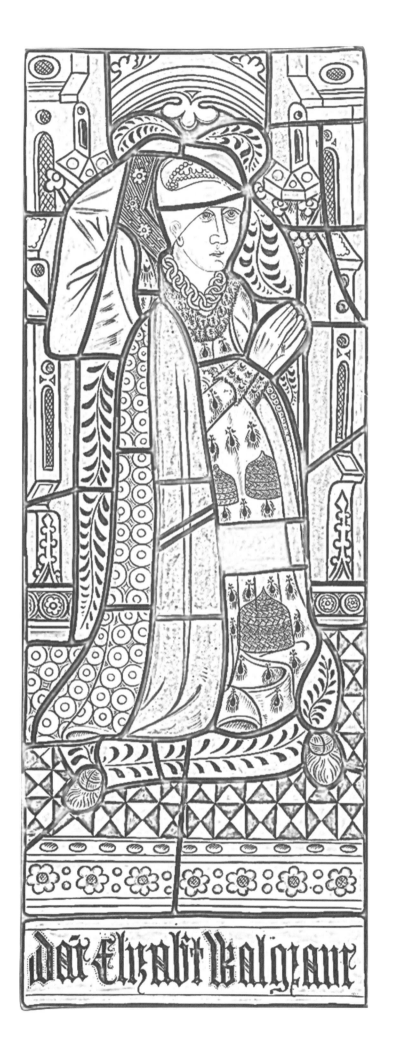

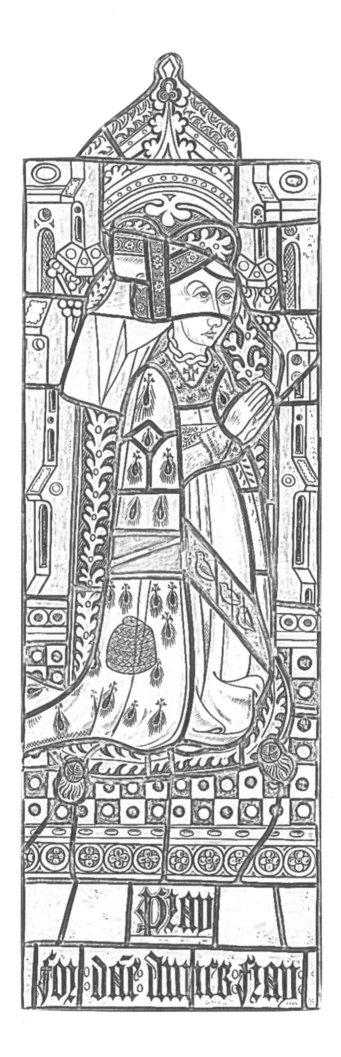

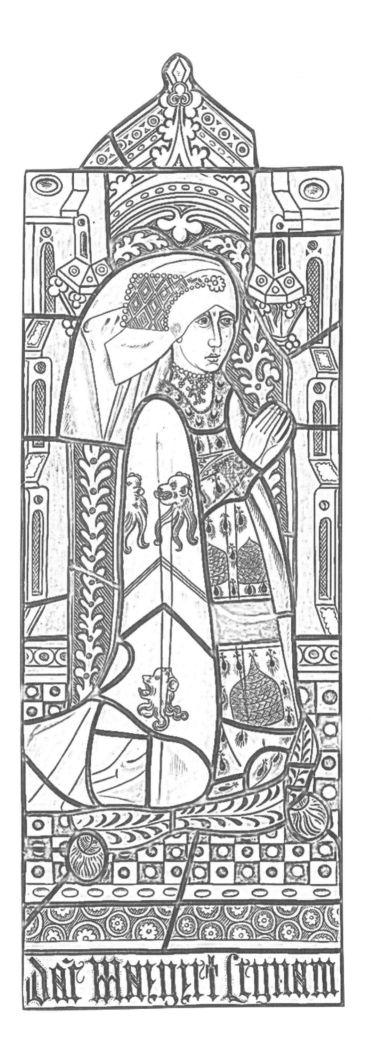

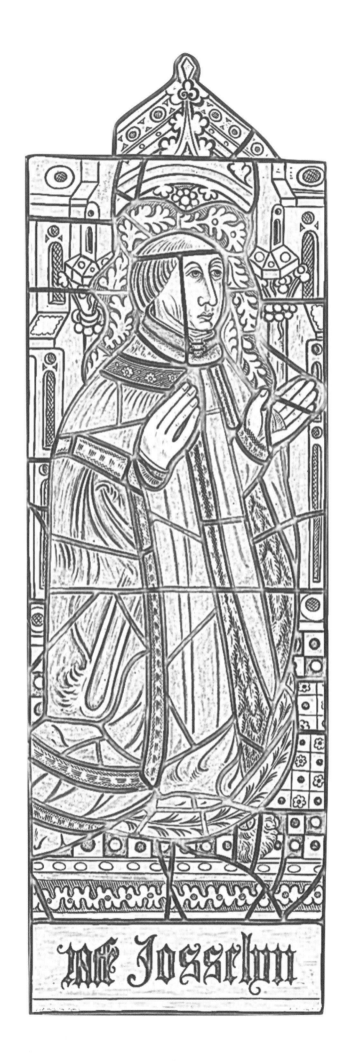

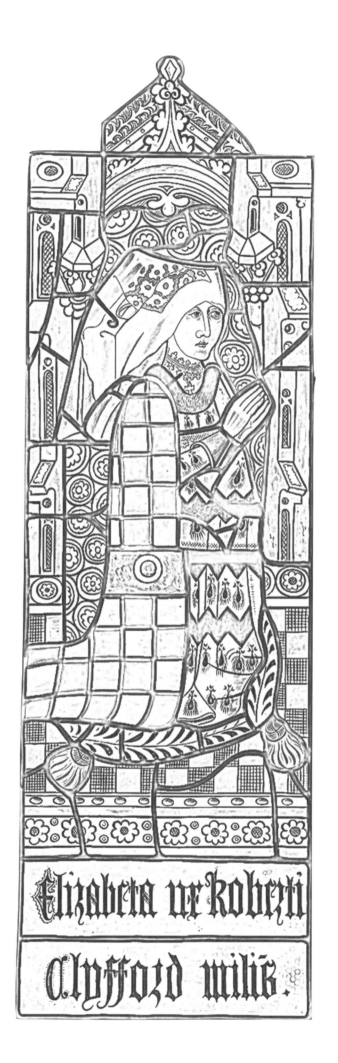

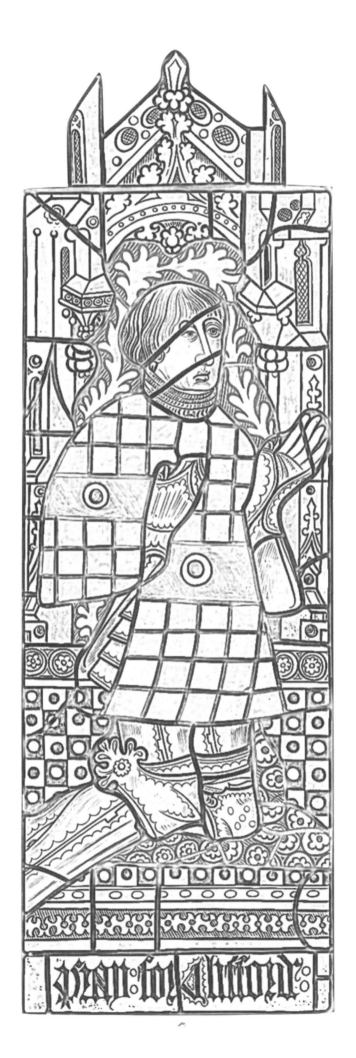

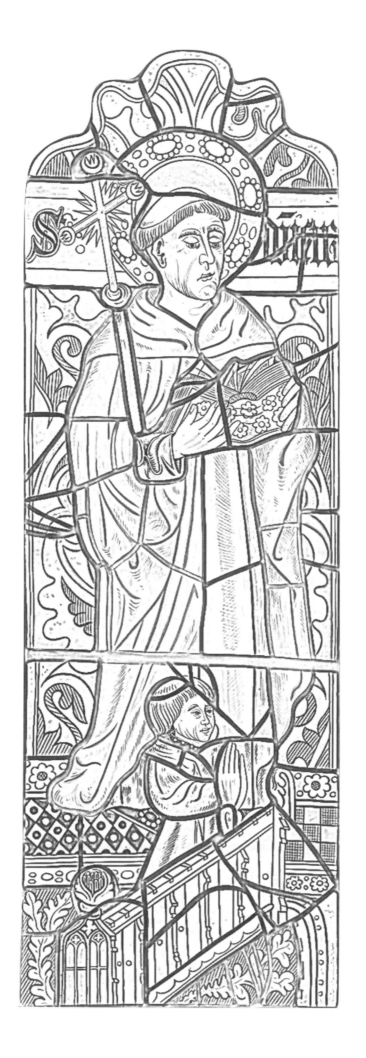

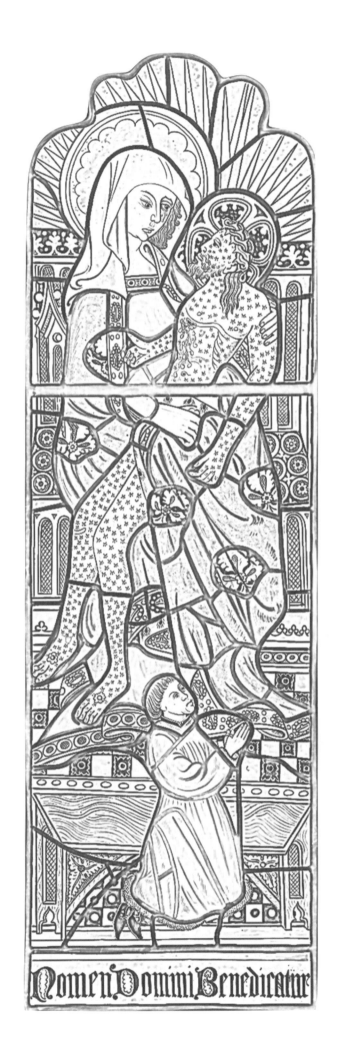

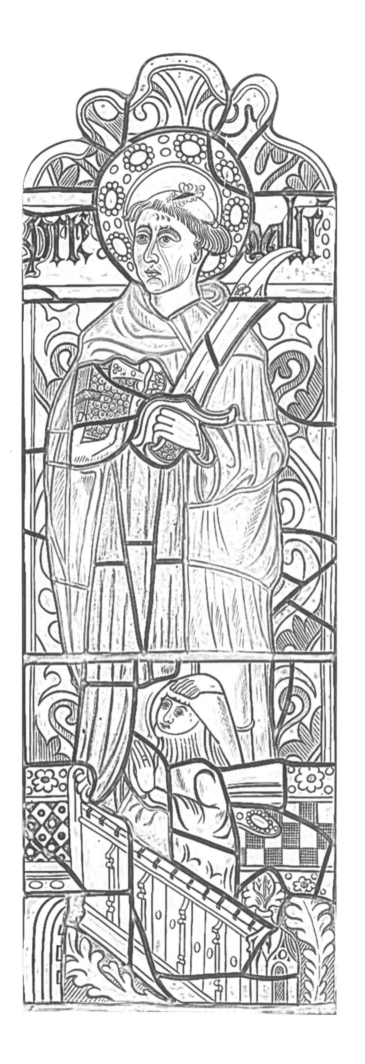

28

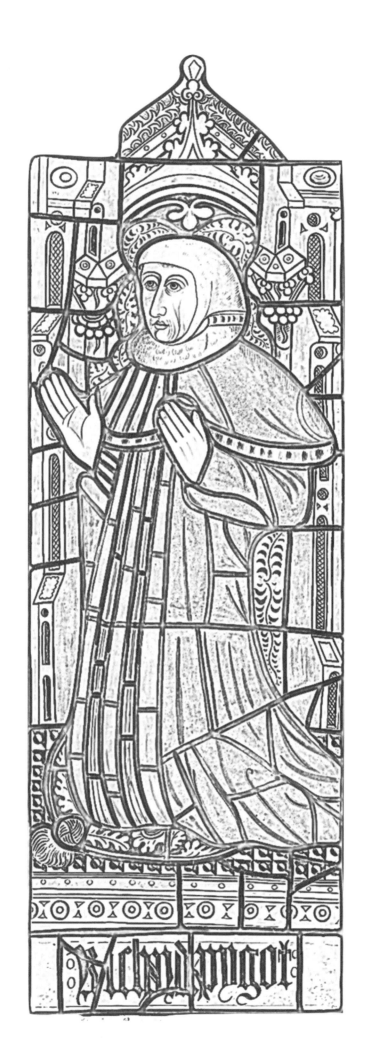

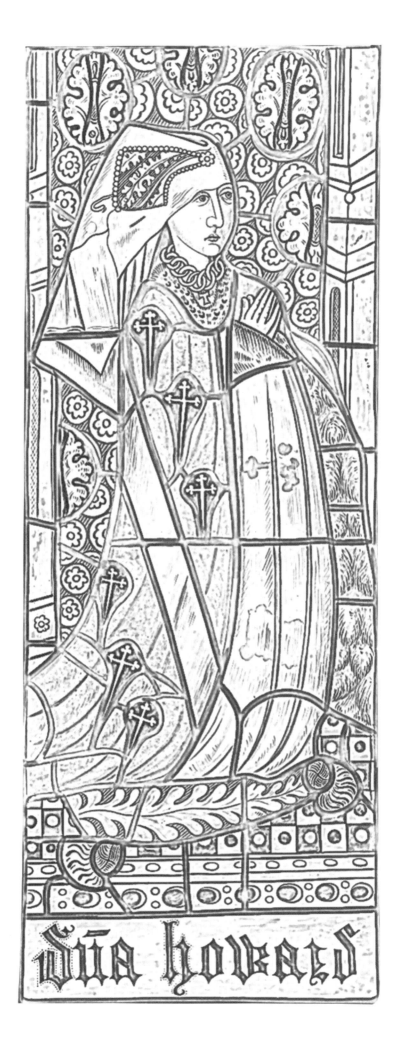

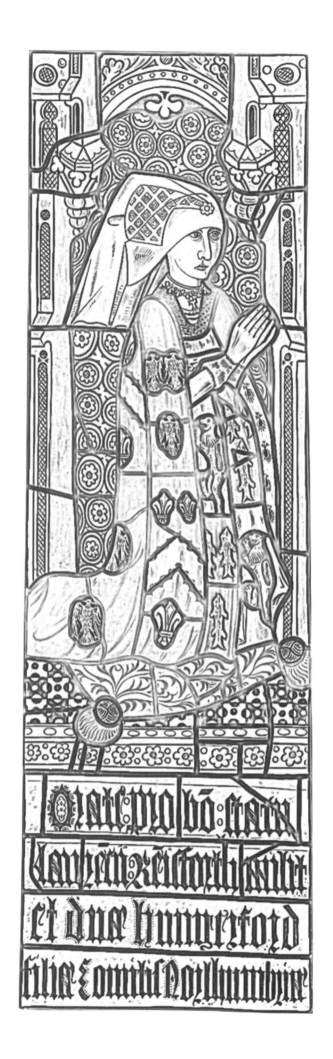

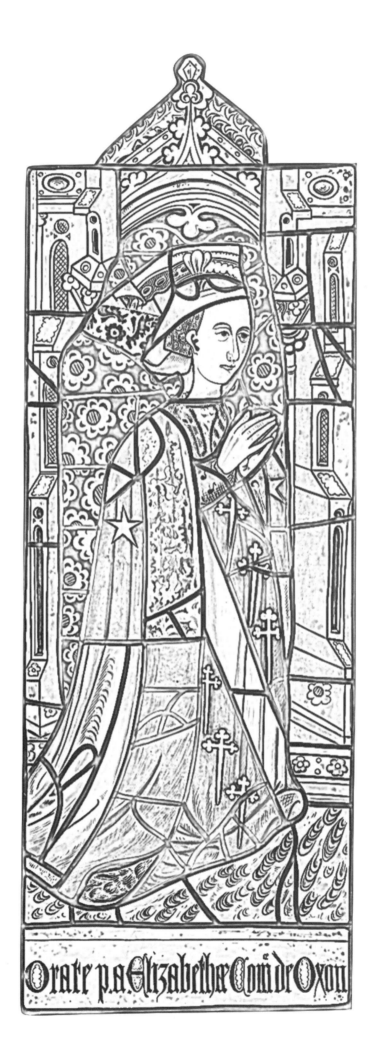

Orate p. a. Elizabethe Com de Oxon

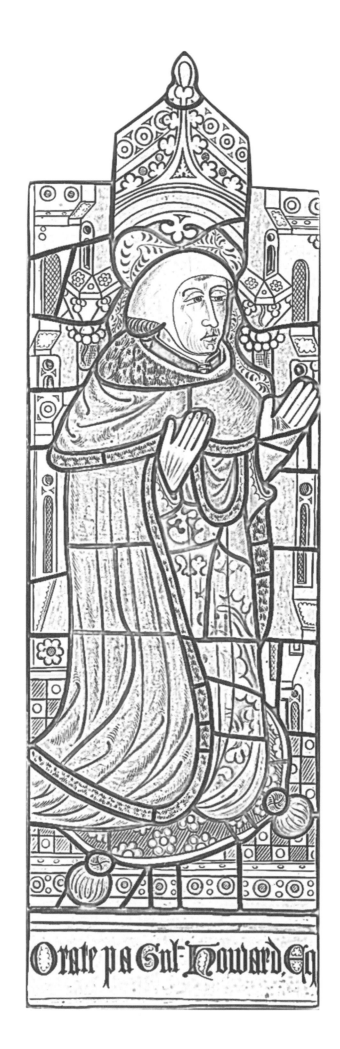

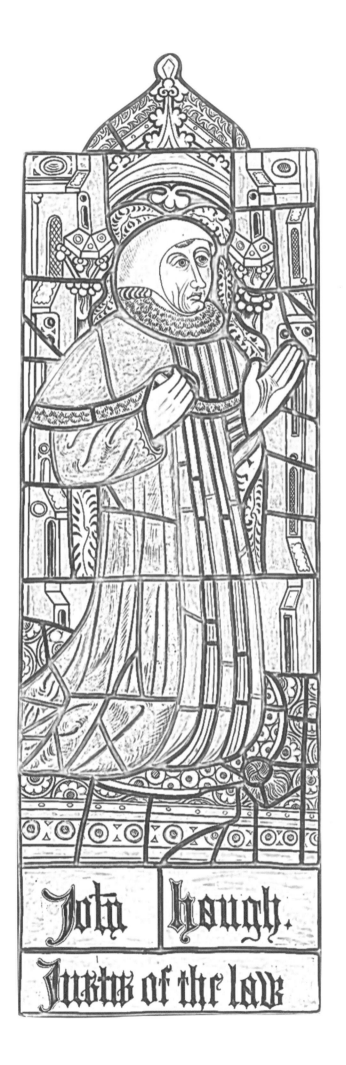

John hough.

Justis of the law

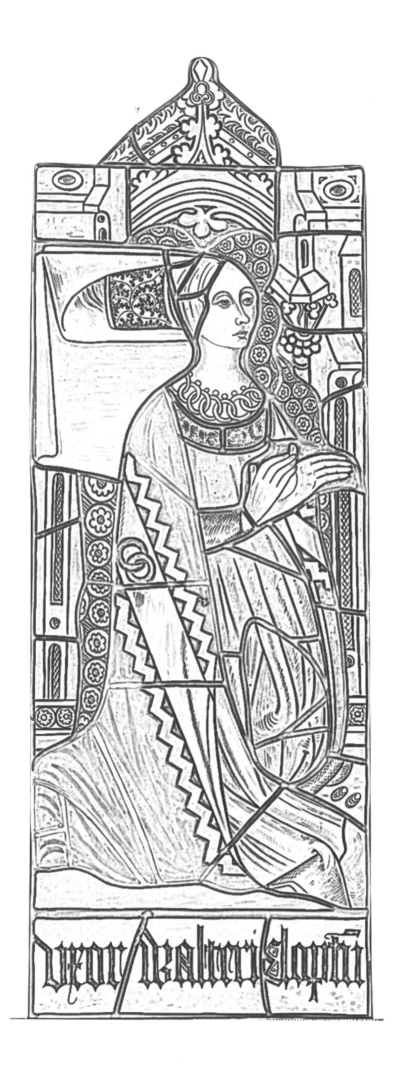

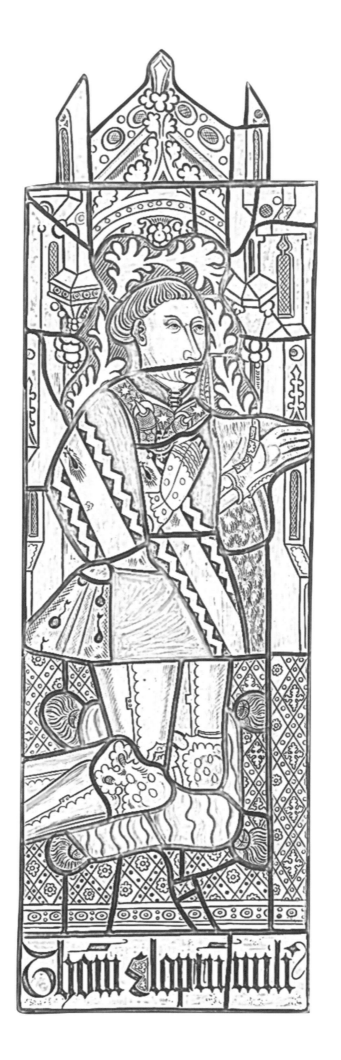

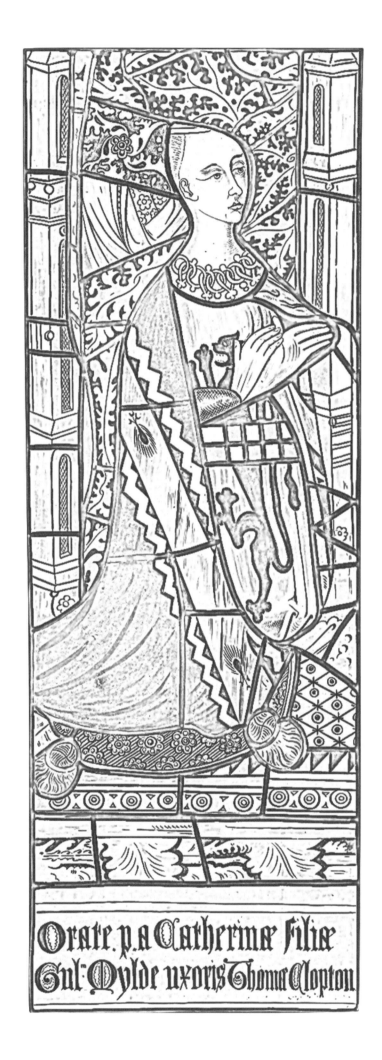

Orate. p. a Catherinæ filiæ
Gul. Mylde uxoris Thomæ Clopton

Who's who in the windows
Index of plates

1 Margaret, daughter of Sir John Bernard of Cambridgeshire, and wife of Thomas Peyton: married about 1451. Peyton was connected with the Cloptons by marriage

2 St Edmund, King of the Eastern Angles in the ninth century, and England's patron saint in medieval times. The figure below him is probably Richard Hengham, Abbot of Bury St Edmunds, who died in 1479

3 Sir Thomas Peyton, High Sheriff of Cambridge and Huntingdon. Born 1418, died 1484. He was connected with the Clopton family through his second wife, Margaret Frances

4 St Gabriel

5 St Michael

6 Anna, wife of Sir John Broughton, only daughter of John Denston and his wife Catherine. The latter was the daughter of Sir William Clopton and sister of John Clopton. Anna was therefore John Clopton's niece

7 John Denston of Denston Hall, Suffolk. He married Catherine, daughter of Sir William Clopton in around 1440-50, and was John Clopton's brother-in-law

8 Dorothy, wife of Thomas Curson (married around 1470-80) and daughter of John Clopton

9 Elanore, wife of Sir William Tyrell, who was executed on Tower Hill with the Earl of Oxford in 1462. She was the daughter of Robert Darcy and sister of John Clopton's wife Alice Darcy. Her son Sir Thomas Tyrell was Sheriff of Essex, 1482

10 Sir Thomas Montgomery, Knight of the Garter, of Faulkbourne Hall, Essex. Died 1489

11 Anne Montgomery, daughter of Robert Darcy and sister-in-law of John Clopton. She married Sir John Montgomery, brother of Sir Thomas Montgomery. Sir John was executed on Tower Hill with the Earl of Oxford in 1462. Anne was the closest friend of the Duchess of Norfolk, who directed in her will that the pair should be buried as close together as possible

12 John Gedney, Lord Mayor of London in 1427 and 1447. He married Elizabeth, daughter of Sir William Clopton

13 Elizabeth, daughter and heiress of Lord Fitzwalter and wife of John, Lord Dynham, Knight of the Garter, who died in 1505

14 Robert Cavendish, Serjeant at Law. He was the second husband of Elizabeth Clopton, sister of John Clopton and widow of John Gedney, Lord Mayor of London

15 Robert Crane of Chilton, near Sudbury. He married Anne, daughter of Sir Andrew Ogard

16 Sir Thomas Rokewode (or Rookwood) who married Ann, daughter of John Clopton. He died in 1520

17 Anne, wife of Robert Crane of Chilton, near Sudbury. Daughter of Sir Andrew Ogard of Buckenham, Norfolk

18 (left) Elizabeth, daughter of John Talbot, 1st Earl of Shrewsbury and wife of John Mowbray, Duke of Norfolk, who died in 1475. Local legend has it that this picture was the inspiration for illustrator John Tenniel's depiction of the Queen of Hearts in Lewis Carroll's *Alice's Adventures in Wonderland*
(right) Elizabeth, daughter of Frederick Tilney and wife of Thomas Howard, Earl

of Surrey, who commanded at the Battle of Flodden and later became Duke of Norfolk. She died in 1513

19 Elizabeth, daughter of Sir John Fray and wife of Sir Thomas Waldegrave. The latter was knighted by Edward IV at the decisive Battle of Towton in 1461

20 Agnes Danvers, wife of Sir John Fray, Lord Chief Baron of the Exchequer, 1436-48. Her second husband was John, Lord Wenlock, who was killed at the Battle of Tewkesbury in 1471. Her third husband was Sir John Say. John Clopton was her executor

21 Margaret, daughter of Sir John Fray and his wife Agnes, and wife of Sir John Leynham. She founded a chantry in the Church of St Bartholomew-the-Less in the City of London in 1481-2. Her sister was Lady Elizabeth Waldegrave

22 Sir Ralph Josselyn, Lord Mayor of London in 1464 and 1476. He married Elizabeth Barley, who survived him and married Sir Robert Clifford

23 Elizabeth Barley, wife of Sir Ralph Josselyn, twice Lord Mayor of London, and Sir Robert Clifford

24 Sir Robert Clifford, Knight of the Body to Henry VII. He was the first person of any importance to appear in support of Perkin Warbeck, the pretender who claimed to be Richard, Duke of York, the younger of the murdered Princes in the Tower

25 St Francis. The figure below him is believed to be William Quaytis, a church restorer living in Long Melford in 1481 who contributed to the construction of the high altar

26 Mary holding the crucified body of Jesus. The history of the figure below is unknown

27 St Peter

28 Richard Pigot, judge. Serjeant at Law, 1464. King's Sergeant, 1468. The Pigot family were connected to the Cloptons through the marriage of Sir Walter Clopton to Elizabeth Pigot

29 Lady Howard, wife of Sir John Howard, who was made 1st Duke of Norfolk (in the third creation) by his mentor Richard III, and died with him at the Battle of Bosworth in 1485

30 Lady Hungerford, wife firstly of Sir Thomas Hungerford and later of Sir Laurence Reinsforth. She was born Lady Ann Percy, daughter of the Earl of Northumberland. The latter was killed at the Battle of St Albans in 1455

31 Elizabeth, Countess of Oxford, daughter of Sir John Howard and wife of John de Vere, 12th Earl of Oxford. Her husband and eldest son Aubrey were executed on Tower Hill in February 1462, on charges of conspiring with Margaret of Anjou, wife of the deposed Henry VI. John Clopton was imprisoned with them but obtained a pardon

32 Sir William Howard, Chief Justice of the Court of Common Pleas

33 John Haugh, Serjeant at Law, 1486; Judge of Common Pleas, 1487

34 Elizabeth Pigot, wife of Sir Walter Clopton, third son of Sir William

35 Sir Thomas Clopton, father of William and grandfather of John. Died 1384. He was the first of the family to own Kentwell Hall, through his marriage to heiress Catherine Mylde

36 Catherine, wife of Sir Thomas Clopton and daughter of William Mylde of Clare, Suffolk. She brought the Kentwell estate to the Clopton family. She later married Sir William Tendring and died in 1403

Hamlet Watling

The illustrations for colouring in this book are not taken directly from our stained-glass windows, but from a collection of watercolour copies made of the windows in the late 19th century by a Suffolk antiquarian and schoolteacher, Hamlet Watling (1818-1908).

We are grateful to the Hyde Parker family of Melford Hall, and to Lorraine Hesketh-Campell of the National Trust, for granting us access to the family's collection of Watling images and for giving us permission to use them.

The biographical information in the plate descriptions is largely taken from Sir William Parker's painstaking handwritten annotations, made in or around 1877.

Preserving our glass

After centuries of corrosion and microbial growth, our magnificent stained glass at Long Melford is in peril. We need to clean and protect the glass, not just to restore its brightness but to ensure it survives for future generations. This will cost around £800,000.

At the time of writing, we are about a third of the way towards reaching that target. Thanks to a generous donation from a US descendant of John Clopton, and another in memory of Melford resident Joy Hood, we've already restored one of our eight bays and the glass from two more is currently being conserved at specialist studios at Canterbury Cathedral.

We still have to raise money for the rest of the project, with donations large and small. All proceeds from this book will go to the restoration fund. Simply by purchasing it, you have brought us a little closer to our target. We're very grateful for that support.

For further information go to www.longmelfordchurch.com/visiting/stained-glass/